THE CARDIFF TAPES (2019)

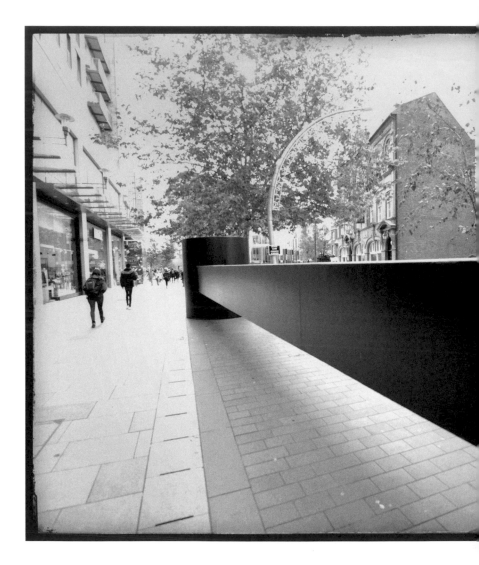

THE CARDIFF TAPES

(2019)

GARTH EVANS

TEXT BY ANN COMPTON

SOBERSCOVE PRESS | CHICAGO

Soberscove Press
Chicago, IL
soberscove.com

The Cardiff Tapes (2019) © 2023 Soberscove Press and Garth Evans

"Anything but Simple" © 2023 Ann Compton

Image Credits: Garth Evans: pp. 34–35, 36, 38–39; Hannah Firth: pp. 37, 41, 42, 43, 44–45; Catherine Angles: p. 40; Mark Orchard: p. 4, 46; Anthony Stokes, p. 81

Library of Congress Cataloging-in-Publication Data

Names: Evans, Garth, 1934– interviewer. | Compton, Ann (Art historian)
Title: The Cardiff tapes (2019) / Garth Evans ; text by Ann Compton.
Identifiers: LCCN 2023012077 | ISBN 9781940190334 (paperback)
Subjects: LCSH: Evans, Garth, 1934– Untitled. | Public art—Wales—Cardiff—Public opinion.
Classification: LCC NB497.E93 A77 2023 | DDC 730.9429—dc23/eng/20230503
LC record available at https://lccn.loc.gov/2023012077

ISBN 978-1-940190-33-4
Design: Rita Lascaro
Copyediting/Proofreading: Yelena Kalinsky
First Printing, 2023
Printed in the United States

Distributed by
ARTBOOK | D.A.P.
75 Broad Street, Suite 630
New York, NY 10004
artbook.com

Frontispiece: Photograph by Mark Orchard, 2019. Courtesy of the artist.

This book is dedicated to my partner Leila Philip,
whose love, interest, support, and encouragement made
all that is documented in these pages possible.

CONTENTS

RETURNING THE SCULPTURE | GARTH EVANS

When curator Jon Wood introduced me to publisher Julia Klein in 2013, I had all but forgotten a tape recording I had made in Cardiff in 1972. Jon had suggested to Julia that I had valuable archival material she might be interested in publishing. Julia and I discussed various possibilities, and in 2015, she published *The Cardiff Tapes (1972)*, with the transcript of the 1972 recording and texts to contextualize it, written by myself and Jon.

I had made the recording by asking people, anonymously, what they thought of a very large steel sculpture—forty feet long and weighing about three tons—that had been installed the previous day in the Hayes in Cardiff. I had asked the same question of everyone, I did not respond directly to inquiries, and I turned off the microphone whenever I spoke. The sculpture, but not the recording, had been part of the Stuyvesant City Sculpture Project, a scheme that had placed sixteen sculptures in eight cities across England and Wales for six months. At the end of the six months

the cities had the option of acquiring the works permanently; none did.

I had been conscious that placing a large enigmatic object on a busy sidewalk in a mixed-use neighborhood close to the center of the city might be taken as a provocative act. With this in mind, I had produced a work that I thought would be invulnerable to any hostility that it might stimulate. The sculpture was made from quarter-inch steel plate, and its form was too simple to be easily obscured by the graffiti and posters with which I anticipated that it would be decorated.

I had wanted the sculpture to challenge people encountering it to think about what it might represent to them, personally. The simple form of the sculpture, like a functional tool, was, in my mind, an homage to the industries that had been the backbone of the South Wales valleys: steel making and more particularly, coal mining. The men in my mother's family had been coal miners, and I was aware of the hardship that that work entailed as well as the close-knit communities that had been built in the small towns and villages where the mines were located. In 1972, most of the mines, no longer economically viable, had closed. The steel mills were soon to follow.

My feelings about people's responses to this sculpture were mixed. Nobody that I recorded made any connection between the large black steel object that confronted them and the coal or steel industries. I had chosen not to reveal the fact that I thought of the sculpture as a memorial to the men and boys whose lives had been cut short in one of the many disasters that were a tragic legacy of the coal mining industry. I had some hope that the sculpture

might suggest itself as something of this sort to other people, but most people were either baffled or annoyed. Far from welcoming the sculpture as an opportunity to speculate, nearly all the people I spoke to resented the presence of this object; it was something new, unanticipated, and in their way. The small children, however, were an exception: they were delighted. One of them declared that he wanted "a hundred more like it."

In general, the interviewees wanted to know what the object's purpose was, what did it mean, why was it there, what authority was responsible? They wanted answers from me rather than to take the risk of engaging with it directly themselves and articulating their own ideas about it. The resulting recording was both sad and funny, at times hilarious. The transcript read like the rough draft of a script for a play written by Samuel Beckett or perhaps an episode from Monty Python. Indeed, it was eventually made into a play by my partner, the writer Leila Philip, and staged by 3A Productions at the famous Duplex in Greenwich Village, and then again in Cardiff by the Everyman Theater Company.

• • •

While writing the introduction to *The Cardiff Tapes (1972)*, I found myself wondering about the fate of the Cardiff sculpture. It was large and virtually indestructible, yet I had no idea what had happened to it. I remembered a colleague some years ago telling me he had seen my sculpture, painted gray instead of black, outside a college somewhere in Leicestershire. I set out to find it, asking friends in the UK for help. At some point I was told that the sculpture was at a college called Charnwood in Loughborough.

I searched on Google Maps, found the town of Loughborough, found the college, zoomed in, and saw my sculpture!

Seeing my sculpture again, but from somewhere very high up and a long way away, I started to imagine returning it to Cardiff and putting it back in the Hayes. What if I were to make a second recording? Would it echo the existing document? If not, how, and in what ways, would the responses of people to the sculpture be different from those that I recorded so long ago? Above all, if it were to happen, it would be a unique event. I knew of nothing comparable, a sculpture reappearing decades after it had vanished. When I told people of this rather wild and somewhat impractical idea, it was so enthusiastically received that I began to feel obliged to try to make it happen.

• • •

I first shared the idea with Nicholas Thornton, Head of Modern & Contemporary Art at the National Museum Wales, in February of 2014. By the end of that year, with Nicholas's input and encouragement, I was committed to finding a way of returning the sculpture. Although the Museum could not be directly involved in the project, Nicholas arranged a first meeting on March 24, 2015, in the Waterloo Tea rooms in the Wyndham Arcade, just around the corner from the Hayes. Present, in addition to myself and Nicholas, were Ben Borthwick, an independent curator who was interested in the project; Ruth Cayford, the Visual Arts Manager of Cardiff City Council; and David M. Gibson, a student from Central St. Martin's School of Art in London. I almost fell off my seat when Ruth said that the Hayes and the whole area adjacent to it, which

is the heart of the city, was now privately owned. The first hurdle we would face therefore would be to obtain permission from the current owners of the site.[1]

David Gibson was a very enterprising student at Central St. Martin's who later came with me and several other people affiliated with CSM on a trip to Loughborough in June of 2015, to see the sculpture. The visit had been organized by Elizabeth Wright, a senior tutor at the School. Another tutor, Anthony Davies, had organized a project in which a small group of students had investigated various aspects of the 1972 sculpture and recording. I had been impressed by the work they had done, which included, among other things, making contact with people in Cardiff who remembered the sculpture from the six months that it was in the Hayes, all those years ago.

Interestingly, the students found it difficult to understand my wish to transport the original object back to Cardiff. They suggested I make a replica of it out of some light and easy-to-manipulate material. They proposed that a version made from plywood—or even an inflatable version—could be produced for far less than the cost of transporting the original work just a mile

1 In 1972, the Hayes was controlled by Cardiff City. However, by 2019, it was the property of St David's Partnership, a joint venture of Land Securities and Intu Properties PLC, as the company is known locally. The partnership had invested £675 million and opened a "spectacular" new retail destination in the city. I was not directly involved in obtaining permission to place my sculpture in the Hayes on either occasion so I can only speculate about the reasons that the city agreed to its placement there in 1972 or why Landsec agreed in 2019. It was also necessary in 2019 to obtain permission from the proprietors of the businesses in the immediate vicinity of where the work was to be placed; this was not done in 1972. I would speculate that in 2019, people thought that the sculpture could draw people to the Hayes and so increase the potential for commercial activity in the area. In 1972, the city would not have stood to gain financially from the presence of the sculpture, but perhaps it was thought that there could be a cultural benefit.

or two. I suggested that they make a substitute version and place it alongside the original sculpture. I believe that had we been able to compare their version with the original work, I could have convinced the students that, for my purposes, it was essential to have the original object. For the students, the sculpture's value lay in an abstract realm. For them, the actual physical object was just one of many possible embodiments of their concept of the object. For me, the object itself had value. It had a life—its mute, dumb, unique presence existed outside of, and to some extent in defiance of, anyone's idea of it, or anyone's thoughts about it. A replica in a different material would be the same as the original only in an abstract realm, not in the actual physical world that we all live in.

My feelings upon seeing the sculpture again after more than forty years were mixed—I was moved, yet deeply saddened. The sculpture was impressive and I was surprised by the courage and audacity that my younger self must have had to produce it, yet I was upset to see that the work had been so neglected and that it was very poorly sited. As I had been told, it was now painted gray instead of black, and the graffiti painted on it when it was in Cardiff remained just visible through the layer of gray paint. It was beginning to rust and there were deep scratches on the surface, the result of deliberate acts of vandalism. While it was upsetting for me to see that my work had not been properly looked after by those in whose care it had been placed, it was even more difficult for me to recognize that I, too, had neglected this important work.

Before going to the college and seeing the sculpture, my goal had been to recreate the original six-month installation and make a

second recording by returning the work to Cardiff. But, after visiting Charnwood, I became convinced that I needed to rescue my sculpture.

. . .

In August of 2015, Emma Price, who runs the independent arts consultancy EMP Projects in South Wales, came into the picture. Emma had been introduced to the idea of returning the sculpture by Mike Tooby, a professor at Bath School of Art and Design and an independent curator. Mike had previously held the post of Director at the National Museum and Gallery in Cardiff, and, having heard about the scheme, offered to give whatever help he could. There was a series of promising leads, each giving me renewed hope, but nothing came to fruition.

Meanwhile, Jon Wood, then Head of Research at the Henry Moore Institute in Leeds, had begun to organize a major exhibition about the 1972 City Sculpture Project for the Institute. The exhibition opened in November 2016. In doing the research for this exhibition, Jon had contacted Tony Stokes, who had been an assistant to Jeremy Rees, who, as director of the Arnolfini Gallery in Bristol, had organized the City Sculpture Project. Tony and I had been friends when we both lived in London. I can recall endless games of Monopoly in the Camden Town home of the sculptor Barry Flanagan, where Tony was living. I seem to remember Barry always winning these games, but I had completely forgotten giving Tony a small drawing of the Cardiff sculpture. We reconnected over this drawing, which Tony had kept and offered to lend to the HMI for the exhibition in Leeds.

Hannah Firth, Director of Programs and then Deputy Director at Chapter, a thriving arts center in Cardiff, was told about the idea of bringing the sculpture back to the city. A crucial meeting with Hannah, Nicholas Thornton, Emma Price, Ruth Cayford, and Tony Stokes was held in July 2016. I was absent. As a result of this meeting, all further planning was handed over to Chapter. This made sense, as it was also proposed to organize an exhibition of my work at Chapter to coincide with the return of the 1972 sculpture. From then on, working in association with her staff at Chapter, Hannah became the primary architect of the project.

It was Hannah who introduced the project to the Art Fund, a British independent membership-based charity that raises funds to aid in the acquisition of art works for the nation. She made a successful application to the fund's Art Happens program, and the project of bringing the sculpture back to South Wales was adopted into this program. A crowdfunding campaign was planned, it was successful, and then there were new obstacles.

The campaign was built around the idea that the sculpture was made for Cardiff and that it should be restored and returned "home" to South Wales. It was understood to be a memorial to the mining industry. All of this was, of course, providing the background information that I had successfully withheld when the sculpture first appeared in 1972, and which I had hoped to withhold again when the sculpture returned. However, at this point, it felt to me that it would be churlish and self-defeating to object to the way the campaign was being structured. It was more important to me to recover and restore the sculpture than to recreate exactly the circumstances of 1972—a goal that was

already compromised, since the Hayes and its environs had been so utterly transformed.

Before we launched the crowdfunding campaign, however, it had been necessary to ensure that the David Ross Educational Trust, which was responsible for the sculpture on behalf of the College, was willing to give the sculpture back to me. Charnwood College turned out to be one of several institutions under the auspices of the Trust. A long and tortuous series of exchanges began when Hannah negotiated an agreement with the Trust based on my belief that the sculpture had been taken to Leicestershire on loan, and although it had been at the college for many years, I remained its owner.

In 1972, while the sculpture was still in Cardiff, I had left the UK upon accepting a visiting professor position at the Minneapolis College of Art and Design; it was my first visit to the US. On returning to London later in the year, it apparently had not occurred to me to inquire as to the whereabouts of this massive sculpture. Stewart Mason, head of the Leicestershire Education Authority and one of the selectors for the Stuyvesant City Sculpture Project, was a good friend of my dealer at the Rowan Gallery, Alex Gregory-Hood. It appears that when it became necessary for the work to be removed from the Hayes, these two men had arranged that the sculpture would be taken to Leicestershire, perhaps pending my return. However, I have no documentation of this, nor any memory of being told about it.

There was also no evidence available to show that Leicestershire had purchased the sculpture, and it was clear that the Trust had

not and could not afford to maintain the work. The agreement with the Trust contained a caveat stating that if documents surfaced in the future showing that Leicestershire had actually paid for the sculpture, we could revisit the issue.

Unfortunately, after we had secured the funds necessary to restore and transport the sculpture, a new person at the Trust refused to honor the agreement. Despite Hannah's best efforts, the person who had made the agreement had retired before signing it. His successor asserted that the sculpture belonged to the Trust and said she would do the research to find the documents that would prove this. Meanwhile, to accommodate our schedule and have the sculpture in Cardiff in time for the opening of my exhibition, the Trust would allow us to borrow the sculpture with the understanding that we would return it to the college after restoration and six months in Cardiff. We had raised funds saying that the sculpture was made for Cardiff and that it would be given back to South Wales, where it belonged. It would have been improper and probably illegal for us to use those funds to restore the work only to then hand it back to the college.

No new formal documentation was discovered to show that Leicestershire had purchased the sculpture, but an entry in a book was claimed as sufficient to prove that the work had been acquired by Leicestershire. The book, *Public Sculpture of Leicestershire and Rutland*, published in 2000 by Liverpool University Press, stated that my sculpture had been purchased by Leicestershire with help from the Arts Council for one thousand pounds. However, no primary source is quoted in the book, and none was found.

The interest that had been generated by the crowdfunding campaign had possibly given the Trust's representative the idea that the sculpture might be important, and she probably did not want to be held responsible for giving away a potentially valuable asset. She said she wanted to have the work valued. At this point, exasperated, I informed the Trust that I would disown the sculpture and would not allow it to be attributed to me while it remained in its current condition. Its value was therefore the value of the material, as scrap. I was outraged and more determined than ever that the Trust's neglect of my sculpture should be brought to an end. Seeking to ensure that the Trust either restore and resite the sculpture or return it to me, I engaged legal representation. Unwilling to pay for the restoration of the sculpture, the Trust gave it back to me for the one thousand pounds they claimed had been paid for it in 1972.

· · ·

The restored sculpture was due to arrive in Cardiff in time for the opening of my exhibition on September 13, 2019.[2] Performances of 2A Productions' play, *Cardiff*, were scheduled for the following weekend, and rehearsals were well under way. One final delay prevented this schedule from being followed, and so the opening of the exhibition and performances of the play went ahead, but without the sculpture having been returned.

2 Prior to all of this, Emma Price had been to Charnwood to see the sculpture and had obtained estimates for the cost of restoration. The restoration was undertaken by setWorks, a company based in Croydon with wide experience in the fabrication of works of art. The restoration and all the logistics that were involved in removing the sculpture and transporting it to the setWorks workshop in South London and then to Cardiff were overseen by Hannah and Catherine Angle, program manager at Chapter.

First there was a scare: we were told that to site the sculpture in the Hayes, we should have obtained planning permission from the city. As the Hayes was now private property and its owners had all given permission, as had the businesses in the immediate vicinity of the site, it had not occurred to us that permission from the city might be necessary. Apparently, it had not occurred to the city officials involved in the preparations for the return of the sculpture either. Obtaining planning permission from the city was a lengthy process that would have resulted in a major delay, but, thankfully, the issue was resolved once it was made clear that the installation of the sculpture was to be temporary, that it was not a permanent placement.[3]

The actual delay came at the eleventh hour when we were told that the individual who had undertaken the required risk assessment had to be physically present when the work was being installed (and, I assume, when the risks he had assessed for were being taken). It was therefore upsetting to be informed that our particular risk assessor would not be available on the scheduled date. There were no funds available to have a second risk assessment undertaken at short notice, and so we had to wait until the following week when the original risk assessor could be present.

Finally, at midnight on September 24, a small group that included Hannah Firth, Emma Price, and Tony Stokes assembled in the Hayes to await the sculpture's return. It was a dramatic and tense moment.

3 The sculpture actually ended up staying in the Hayes almost six months longer than intended. It could not be deinstalled in the spring of 2020 as originally planned due to the lockdowns that were put into place in response to the COVID pandemic. It was ultimately removed from the Hayes at midnight on September 15, 2020.

In heavy rain, an enormous truck with lights flashing crawled extremely slowly into the pedestrian way. The first task was to move a huge plant pot containing a full-grown tree. The truck delivering the sculpture was to do this before unloading the sculpture by using its crane to pick up the pot and move it a hundred or so yards away. The transport had come with just the two ties that were necessary to off-load the sculpture. We watched, impatiently, as the crew struggled to find a safe way to use the two ties to lift and move the plant pot. It was impossible—the pot, smooth and slippery in the rain, could not be lifted safely with only two ties; three were necessary. After what seemed an age, it was agreed that the pot would just be dragged a few feet to one side to make room for the sculpture.

A quick look at old photographs revealed that the sculpture would need to be swung around in mid-air if it was to be in the same orientation as it had been in 1972. With only inches to spare between lamp posts and trees, this was done—painfully, slowly, and with great skill. Then, finally, the sculpture had returned. Tony Stokes had been responsible for much of the logistical planning of the City Sculpture Project and was present with me when the sculpture arrived in 1972. I found a wonderful richness in our being there together again in 2019 when the sculpture was reinstalled.

We were all elated, hugs and kisses were shared. Tired and wet, but triumphant, we went off to our beds. I felt satisfied seeing the sculpture perfectly restored and in the Hayes again; it was enough. Nevertheless, hours later I went back out to the Hayes with my tape recorder to make the recording that six years earlier I had imagined making.

THE CARDIFF TAPES (2019)

1ST MAN: I'm on my way to the train station right now.

· · ·

2ND MAN: Uh, don't really have a view, to be honest. What—is
 it, uh, is it, uh, art, or something, or—[pause]. I've
 nothing to say, I'm afraid. I—[laughs]. Okay, sor—

· · ·

3RD MAN: About what? I just noticed it. I haven't been—I
 don't live here, so—why, what is it? You don't
 know what it is? It's a sculpture of sorts, but, uh—
 yeah, what's this for, anyhow?

3RD MAN: Yeah, it's difficult to kind of interpret this one. I
 don't—I haven't really looked at it. [Pause] I say,

it'd be a good place to get sun, at a certain time you could lay on it. But yeah, if it's a sculpture, I don't know what the purpose is. Geometry, of sorts? Um, yeah. Triangles, cylinders, you know?

• • •

4TH MAN: What is it?

5TH MAN: I have no idea what it is.

5TH MAN: Right. No, but what—what is it? [Pause] Well, I can't be more help, I don't really know what it is.

• • •

1ST WOMAN: Sorry, I'm—I don't—[laughs]

• • •

2ND WOMAN: What is it? What is it? A wall?

6TH MAN: No, I—I didn't see it here yesterday.

2ND WOMAN: [Laughs]

6TH MAN: Um, yeah, I don't know.

2ND WOMAN: It looks like a black wall. And that's it. [Pause] Come on, mate. [Laughs]

6TH MAN: Oh it—yeah, no, no. It, it looks good there, yeah. Um, uh, I'm not entirely sure what it is, though. Um, but I've got—I—no, I'm not entirely sure what it is, but—

2ND WOMAN: [Laughs]

. . .

7TH MAN: What is it? I have no idea, sorry.

8TH MAN: No idea, as well. Don't have time—

. . .

9TII MAN: I'm not allowed to speak. I'm not allowed to, I'm on the council.

. . .

10TH MAN: [Sighs] *Untitled* by Garth Evans, and it represents an aspect of the coal mining industry. The long, horizontal member, uh, depicts, um, a cutting through, um—well, as you would find in a, in a, in a coal mine. And if you could walk over to it, I would like to point out that many of the seams that were worked in South Wales were this high [motioning], and people were cutting coal when it was half full of water. And I think the one at the other end represents, um, a tool, a hammer. And funnily

enough, I have something with me, which is of this time, which is 1972? And there was a shop just up there called "Green Seal—Green Shield Stamp Shop." When you did your shopping, this is, um, in a supermarket or something, they would offer you discount stamps, which you would then collect. Well, I got this from there. Do you remember these? It's a slide rule. British Thornton's 10-inch slide rule.

10TH MAN: So, this is actually from that time. And I actually climbed on this, but I see there's a sign now saying, "Do not climb." [Indecipherable Welsh] Um, can I add anything else?

• • •

3RD WOMAN: What is it? Wha-what is it? Is it an artwork? I don't know what to think about it. Um, well, I haven't really had a chance to look at it, but, uh, I'm going to say, I always like art, public art. That's always a good thing. Why is it black? I don't have anything else, really, to say about it. I need to look at it a bit more. [Pause] Not going to give me any explanation at all? Oh, okay. Well, it's probably a good thing.

• • •

11TH MAN: It's just something there.

4TH WOMAN: I don't know anything about it. I'm sorry.

. . .

12TH MAN: Here? What is there? Well, I don't know what to say, I'm walking here, you know. I don't know. I just come for a fag, I don't know what—it looks like, like for the skateboard, you know? Like [laughs], I don't know how it looks. [Pause] No, I don't know, mate. What is there? What's that?

. . .

13TH MAN: I don't know. [Pause] I don't know.

. . .

14TH MAN: Oh, it's the, uh, it's to celebrate coal, coal mining, isn't it? But I'm not 100 percent sure what the device is. Uh, it's quite interesting. It's by the chapel, which is, uh, another thing with Wales, isn't it? Chapels and coal mines, not that there's many coal mines. Uh, it's charcoal grey, so it's an industrial color, isn't it? So, and it's in the shopping area, where, I suppose, people might be interested in what they're buying and bargains, rather than history and heritage. But it is good to see the history of Wales in Cardiff, so I think that's a good thing to

see. And the visualization of the industrial past. Uh, sometimes, I suppose, in urban areas, people just go by from one place to the next and have scant regard for industrial activity. And, uh, you know, years ago, the coal mines, uh, pr—brought coal out, and the coal went in the trains, and that went to the power stations, and people switched on the lights. And perhaps they didn't give a monkey's about the fact that the power comes from some-where, and it just—they take things for granted, don't they? So, coal was used for different things, making earlier types of plastics, as well. They used coal in different products, didn't they? So, it's kind of a versatile thing, and today, it's largely been ignored. But the ironic thing is, they're clos-ing coal-fired power stations because of the car-bon issues and carbon footprints, and then they're opening incinerators to burn plastic. So, you know, the circles are there in a different way. And thank you for—my name's Frank. Thanks a lot.

· · ·

15TH MAN: What do you think about this?

5TH WOMAN: What does it represent? What is it?

15TH MAN: Well, it was made in 1976.

5TH WOMAN: Hmm.

15TH MAN: Did you know that? In Cardiff. Did you make it? You know who did, don't you? Come on, you know who made it.

5TH WOMAN: [Laughs]

15TH MAN: Come on, tell us. [Pause] Oh, I see. You've nothing, do you?

5TH WOMAN: I think there's supposed to be a sign there.

15TH MAN: What's it supposed to represent, do you know?

• • •

16TH MAN: Well, I think it's going to be an eyesore, yeah? For all the down-and-outs, all the drunks, the lot. They'll be climbing all over it in the nights, it'll be full of graffiti, so—and it'll be a leaf grabber, won't it? With all these leaves on this tree? So, we'll have to wait and see what happens. And it's here for six months. So, there you're at. That's all I can tell you about it.

• • •

6TH WOMAN: You'll have a lot of graffitiing on it, or whatever, won't you?

17TH MAN: Yeah. Well, you can talk to him, it's all right.

6TH WOMAN: No, it's all right. [Indecipherable Welsh]

18TH MAN: Well, he shows you—

. . .

19TH MAN: Hey man, can I help you?

. . .

20TH MAN: What is it? What is it? Wha—

. . .

21ST MAN: [Laughs] No comment. Going, bye-bye.

. . .

7TH WOMAN: Uh, no. I'm sorry, I-I haven't got time.

. . .

8TH WOMAN: Art installation? Is it an art installation? We're just wondering what it is, actually. It looks like an arrow, um, just curious to see if it's finished or if it's unfinished. But very interesting. Are you going to tell me what it is? It's a secret, is it? Okay. Okay, then. [Laughs] Thank you.

. . .

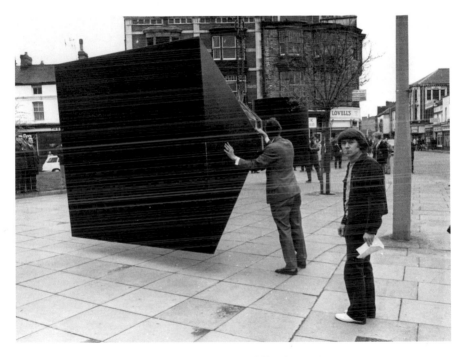

Garth Evans (right) next to *Untitled* on the Hayes in Cardiff, Wales, 1972.

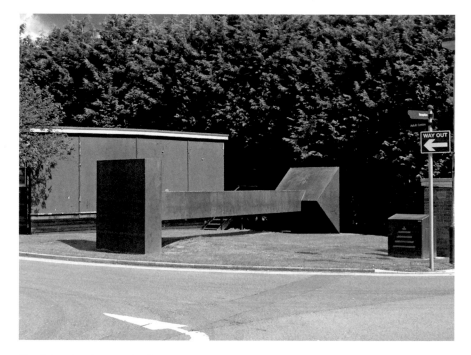

Untitled on the Charnwood College campus in Leicestershire, England, 2015.

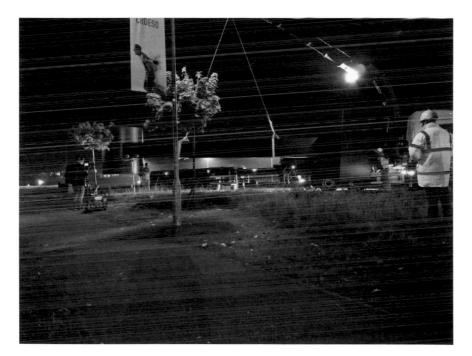

ABOVE: Transporting *Untitled* away from the Charnwood College campus in Leicestershire, England, 2015.

PAGE 34–46: Reinstalling *Untitled* on the Hayes in Cardiff, Wales, 2019.

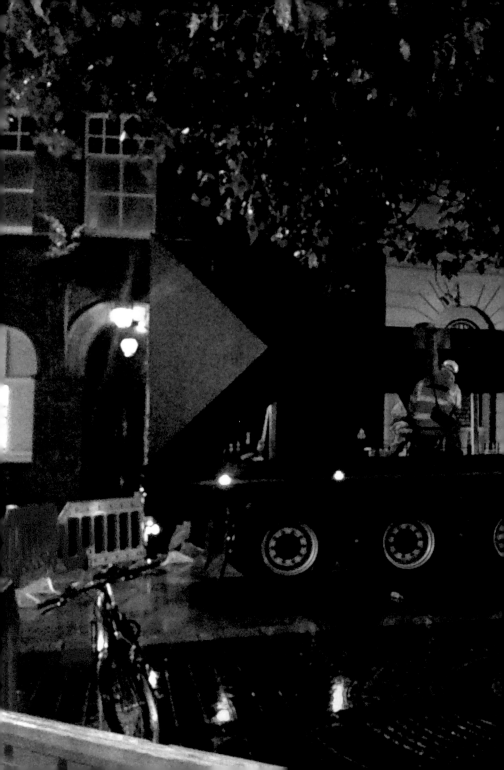

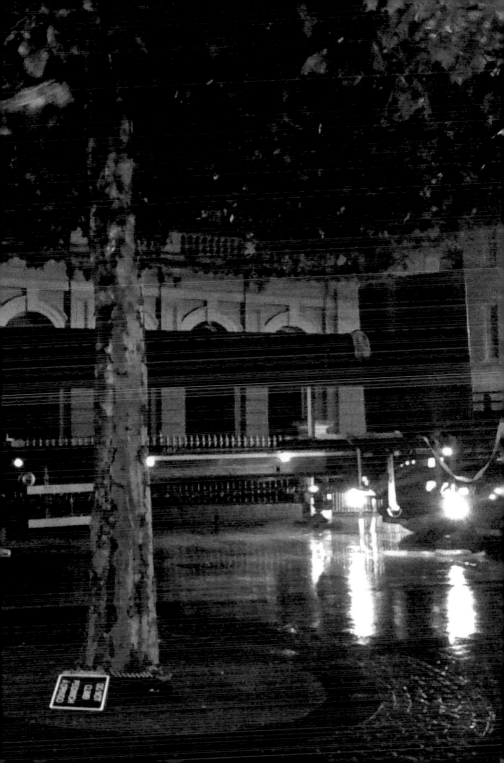

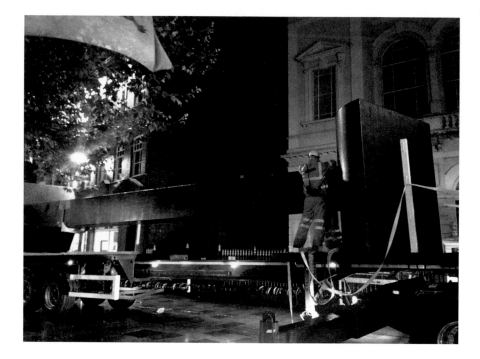

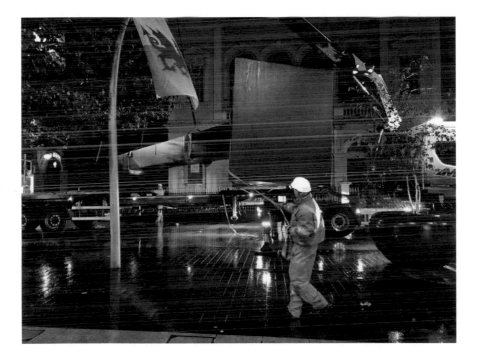

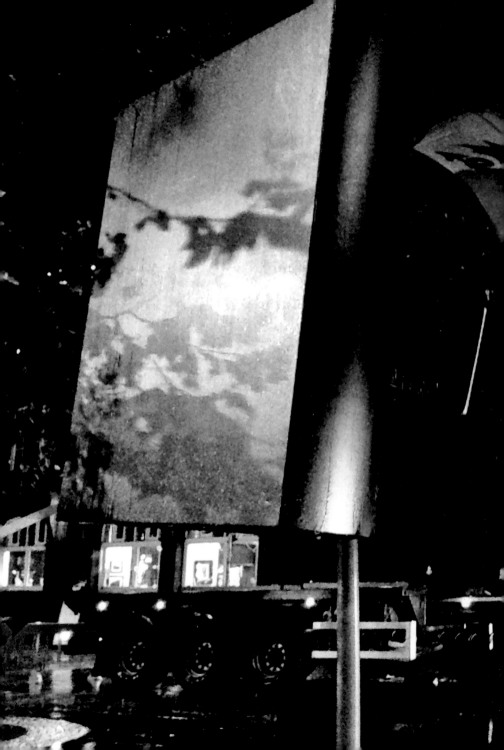

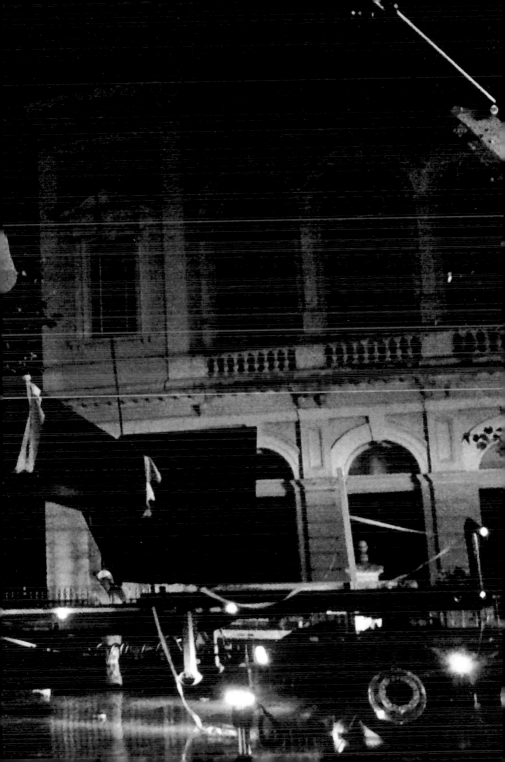

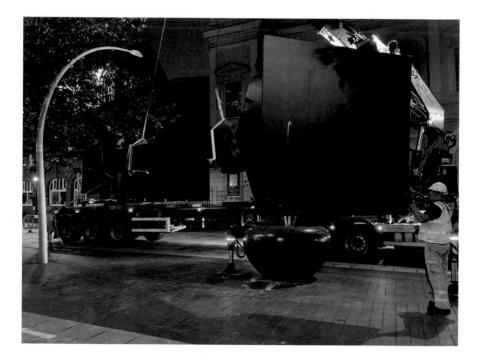

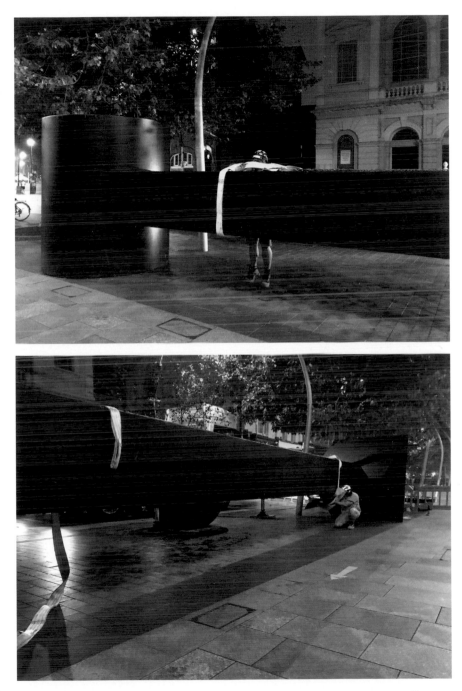

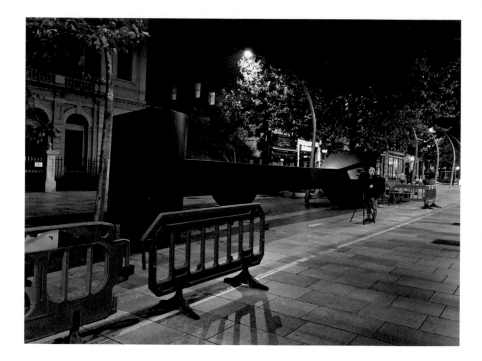

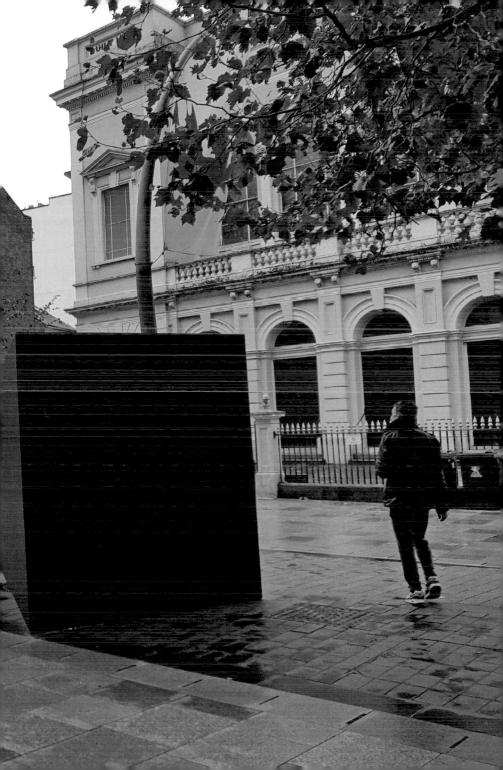

Garth Evans next to *Untitled* on the Hayes in Cardiff, Wales, 2019.

9TH WOMAN: What is it? It's a, it's und—I, I don't know what it's supposed to be. What do you—do you have an explanation of what it's supposed to be? No? All right, it just looks like a, an iron girder, no, I don't think it belongs in High Street. Okay.

• • •

10TH WOMAN: Um, I don't know. I don't even know what it is. What's it meant to be? What?

11TH WOMAN: I think it looks very pretty. I think it attracts a lot of people. It's nice.

10TH WOMAN: It does—

11TH WOMAN: Nice for photography, as well.

10TH WOMAN: —it looks industrial. It looks industrial. Um, but I suppose it's a talking point, isn't it?

11TH WOMAN: Yeah.

10TH WOMAN: Um, putting modern art in—

11TH WOMAN: Yeah, very nice.

10TH WOMAN: —out in the public view. It's a good idea.

11TH WOMAN: Very contemporary.

10TH WOMAN: [Laughs] Yeah.

11TH WOMAN: What's your opinion? What's your opinion? Do you like—

10TH WOMAN: [Laughs]

11TH WOMAN: I think it's nice.

10TH WOMAN: I think it's a good idea for a public space, sharing art with everybody. Good idea.

11TH WOMAN: [Pause] I, uh—look, I, I'm from Australia, so, it's, what, it's a new arty thing, is it? I don't know what it is. What am I supposed to say?

11TH WOMAN: It's different. Yeah, it's different. But fro-fro—n-not from being here, I don't know what it's supposed to represent, so I don't—really can't comment on it, really [laughs]. Thank you.

· · ·

22ND MAN: Well, it looks industrial to me, some sort of fitting for a, a huge mine shaft, or something like that. So, it shows strength.

· · ·

23RD MAN: I'm in a rush, sorry.

24TH MAN: It's interesting. Trying to work out what it is. Um, it's a supersized anchor, perhaps. I'm not sure. What's it supposed to be? What's it supposed to be, sorry?

24TH MAN: Okay, no. I like it. It's pretty good. I've got to dash, anyway. Thank you.

• • •

12TH WOMAN: Well actually, I, um, I was involved in it. I am Steph Anya. I am the one who sent you an email asking about your sculptures for the exhibition. I work with Hannah, in the office.

12TH WOMAN: [Laughs] Um, but I, uh, I've watched the, the play that was, um, to do with the sculpture, at Chapter, and it just started to make me think that art really does—it opens a conversation between people, which I found very fascinating. Because if it wasn't here—you know, looking back in the '70s, you know, how many people just stopped and started talking to each other because of the piece of work? It was really fascinating.

• • •

25TH MAN: Ah, you—I've got—I have a speech impediment, so I don't really record.

25TH MAN: Uh, it's, it's surprising. When I came around the corner, I didn't expect to see it. And then, I like—I like the fact that there's like a, a rounded side, and a sharp side. And it provides a distraction, because I don't like, uh, walking crowds, right now. But, this gives it a welcome distraction from the crowds. And it's, it makes you—that end makes people calm, and this end make-makes me feel more, not stressed, but more aware, or more, more, uh, aware of my surroundings, whereas that, I feel, is more of a, it feels like escapism, and it changes be-between the two ends—because I'm a photographer. And when I was taking— if I take—the pictures I've taken at this end, they're more, obviously they're more geometrical, because it's angular. But they are, they are more stark.

The pictures that I've taken down there are softer. And it, it, the two ends of this, uh—I assume it's a, a sculpture, but the two ends make, make me feel completely different. That end make-makes me feel calm. This end makes me feel more—yeah, it's like I was saying, it's not anxious, but it makes me more, um—I feel more, more aware of my surroundings. But I, I like that, in terms of, like, at that end, it makes me feel, um, like I more escape—it provides some kind of escape, escapism. Sorry, I can't express myself better. It's, it's pretty hard to get my words out.

25TH MAN: I mean, what is it, what is it, like an industrial sculpture? I really like it. I don't—the thing is, the, the, the demographic of people that come in the morning is probably different to the afternoon, and you'll get a different response. I have a feeling, as a, as a street photographer, there are—you get completely different reactions in the morning to the afternoon in terms of art or aesthetic. If I'm taking pictures of people in the morning, they almost like—they don't—they don't mind. And they, and they, uh, but in the afternoon, they're very like, feel very suspicious and don't get what you're doing.

And I find tourists are much more open. If you, if you see Italians or French or Germans, they're much more, uh, open, just to the fact that you're doing something artistic. There doesn't have to be a reason for it, it's just how it makes you feel. But you find with British people, they're much more, "Why are you doing this? What are you doing this for?"

• • •

26TH MAN: No, I don't want, I don't want you recording my reaction. I was just interested in what that thing was, right here, and where it'd come from. It wasn't here yesterday [laughs].

• • •

13TH WOMAN: So, do you know why it's here? Is it going to be a permanent fixture? Okay [laughs].

. . .

27TH MAN: Oh, is it new? Is it new?

27TH MAN: I've never seen it before, so obviously I didn't know if it was new or not, that's all. Thanks.

. . .

28TH MAN: I don't know what it is. What is it?

14TH WOMAN: I think it's no good for somewhere like this. You can't use this. I think it's typical and pathetic, I do, to be honest.

28TH MAN: What is it?

14TH WOMAN: What the hell is it supposed to be, like, isn't it? It's this rubbish they're putting on the ground all the time, isn't it?

28TH MAN: But what, what is it supposed to be?

14TH WOMAN: Is this madness? This is madness. Mad.

28TH MAN: What's it supposed to be?

14TH WOMAN: Crazy. Yeah.

14TH WOMAN: It's crazy, it is. Just crazy.

28TH MAN: How else does it seem?

. . .

29TH MAN: —think about it?

. . .

15TH WOMAN: What is it? [Laughs]

30TH MAN: I don't know what it's—what's it supposed to rep-
 resent? Or what is it?

15TH WOMAN: Bloody awful.

30TH MAN: [Laughs]

15TH WOMAN: [Laughs]

. . .

31ST MAN: I think it's, it says, "Do not climb," but it's obvi-
 ously inviting people to climb.

16TH WOMAN: Yes.

31ST MAN: Then they'll be working at height, and they'll
 fall off, and then they'll sue the artist or the gov-
 ernment or whoever for, for installing it in the
 first place.

16TH WOMAN: Well, they're trying to work out quite what it is.
 Is it going to be up on its end, like a hammer, or
 a—I'm not sure.

31ST MAN: I don't like it, sorry. If you want a, a succinct answer.

16TH WOMAN: It's inviting people to climb. "Do not climb" in-in-
 vites people to climb [laughs]. Okay.

31ST MAN: And you'll get children on there, and of course
 children will play, and no safety rails.

16TH WOMAN: But it's a nice space, I suppose, if you did—were
 able to climb, or had a ladder, or something. It
 would be a nice performing space.

31ST MAN: And safety rails, yeah. Okay, sir?

16TH WOMAN: Okay [laughs].

· · ·

32ND MAN: No idea, because, uh—what's that?

32ND MAN: I'm not from here. I just arrived, only.

32ND MAN: In country, country? Uh, Philippines.

• • •

17TH WOMAN: [Laughs] No, ask him.

33RD MAN: Um, well. So, be disappointed with me because I don't really know what it is, as, as yet. So, I don't know if it goes up or across. I don't really know, so, it's not, it's not—you're not going to get much from me, unfortunately. So, sorry. That's about it [laughs].

33RD MAN: —cross. Do you know?

• • •

34TH MAN: It is absolutely brilliant, and I hope it stays. But it's not, is it? No. I, I absolutely love it. We ought to do more of these things in Cardiff. It's just, I'm going to walk around—I'm going to walk around the other side, because I like it, a lot.

34TH MAN: Get rid of the lampposts, and then it'll be better. Couldn't they find somewhere where it was more open?

34TH MAN: I think it's great. Absolutely fantastic. But it should be in a better place. It should be some-where—it should be somewhere where it's more

open, and visible. Definitely. Still, I—thank you, very much.

. . .

35TH MAN: —neat piece of artwork [laughs].

. . .

18TH WOMAN: We're in a rush at the moment, I'm sorry.

19TH WOMAN: We're in a rush, we're so sorry.

18TH WOMAN: I've got an interview in a minute—

. . .

36TH MAN: [Laughs] What is it?

36TH MAN: But what—yeah, but do you know what it is? Oh, I'm meant to know what it is? Is there a sign that says what it is? Thank you [laughs].

. . .

19TH WOMAN: Sorry, I'm not from here. Thank you.

. . .

37TH MAN: How long is it here for?

37TH MAN:	Please ask me again in six months.
37TH MAN:	What's it made of?
37TH MAN:	What's—how's the steel been tem—what, what is it, carbon steel? What kind of steel?
37TH MAN:	What's your name, sir?

· · ·

20TH WOMAN:	I don't know what it is.
21ST WOMAN:	I don't know what it is.
22ND WOMAN:	Don't know.
23RD WOMAN:	We don't know.
20TH WOMAN:	Is it artwork? An art thing?
23RD WOMAN:	It definitely looks like some kind of art.
21ST WOMAN:	A big bench.
23RD WOMAN:	It's industrial, isn't it? It looks like something industrial, but I'm not sure.
20TH WOMAN:	Sorry.

21ST WOMAN: Very abstract.

22ND WOMAN: Very abstract.

20TH WOMAN: There you go, yeah.

23RD WOMAN: What do you have to say?

22ND WOMAN: A giant's bench [laughs]. I don't know.

23RD WOMAN: A giant's bench, there we are [laughs].

22ND WOMAN: Sorry, we're not good at this. No idea.

• • •

24TH WOMAN: Uh, we were just wondering what it is, really.

38TH MAN: Yeah, we were just wondering what it is.

24TH WOMAN: It's um, yeah.

38TH MAN: It's not offensive. It looks like a crash barrier.

24TH WOMAN: It does [laughs], yeah.

• • •

25TH WOMAN: What, the sculpture? Pretty bland, haven't even

noticed it as I walked past. Um-hum, no reaction really. Just dark, and uninteresting.

• • •

39TH MAN: This? Yeah, of course. Well, it's the first time that I've seen it. Um, I'm not entirely sure what it is. It looks like some kind of public art display, or something. But, um, I'm sure it has some meaning to it, I'm not entirely sure what that might be, but I think, maybe if you are going to do something like this, maybe do something a little more transparent, maybe? Because I'm not entirely sure what it's supposed to mean. I'm not sure if you do, either [laughs]. But, uh, no, it looks okay, I suppose. As I said, it's the first time I've seen it, so I'm not really sure what to make of it. But, but if I had to make a judgment, I'd say no, I don't particularly like it all that much. Yeah. That's, uh, yeah [laughs].

[Silence]

• • •

40TH MAN: Nothing at the moment, because I've only just seen it for the first time. I need to think about it. Do you—what is it intended to be? [Pause] Oh, you're recording this, are you? Oh, well. I don't particularly want to be record—

· · ·

26TH WOMAN: Um, do you know what it, it is? Is it like an art instal-
 lation, maybe? You can't really tell me anything, can
 you? No? Um, well, I have no idea [laughs]. I think
 it's, um, I think it's like an arrow, but in a certain
 way, maybe, pointing you in a certain direction?
 Um, or it could be a piece that you look down, sort
 of like a, like if you were flying over it and you could
 see what it actually is. Um, it definitely makes you
 think [laughs]. Um, it was really nice chatting to
 you, but I've got to head off to the—

· · ·

27TH WOMAN: —build rubbish.

41ST MAN: —clue what it is.

27TH WOMAN: Um, I don't even know what it is. No.

41ST MAN: No, but what is it?

27TH WOMAN: What is it?

41ST MAN: What is it?

· · ·

42ND MAN: Um.

28TH WOMAN: [Laughs]

42ND MAN: Haven't got a clue what it is.

28TH WOMAN: Haven't got a clue, no.

· · ·

29TH WOMAN: —it [laughs]?

30TH WOMAN: I don't even know what it is.

29TH WOMAN: I don't know.

30TH WOMAN: It is obviously some artist thing, but—it looks like
 a hammer.

29TH WOMAN: [Laughs] What is it?

30TH WOMAN: He's not going to say. He wants our opinion.

29TH WOMAN: [Laughs] I honestly don't know what it is, no.

30TH WOMAN: No, it's a waste of time.

29TH WOMAN: No. Haven't got a clue.

30TH WOMAN: Unless I knew what it was. You should have—have
 you got a plaque, somewhere? No.

29TH WOMAN: No.

30TH WOMAN: A plaque to explain it would be a lot more, um—

29TH WOMAN: Useful.

30TH WOMAN: —educated, but anyways. Um, no.

29TH WOMAN: No, nothing.

30TH WOMAN: That's it.

29TH WOMAN: No.

• • •

43RD MAN: Yes, what is it?

31ST WOMAN: [Laughs]

43RD MAN: You tell me what that is. [Pause] Do you know what it is?

31ST WOMAN: Just say you haven't got time, dear.

43RD MAN: Oh. It's probably a waste of public money, again. Have a nice day.

• • •

44TH MAN: It's been here before, yeah? I don't know what it
 is. A sculpture. Artwork.

 • • •

32ND WOMAN: It looks very nice, but I don't know what is it,
 exactly.

33RD WOMAN: [Laughs]

32ND WOMAN: Black arrow? Black arrow?

33RD WOMAN: Yeah, I think it's an arrow, right?

34TH WOMAN: No, it's not. No. What is it? What is it?

32ND WOMAN: Are we done?

34TH WOMAN: I think until, un-unless you write something here,
 he does not explain any meaning, so you need to
 write something in order to explain what is this,
 and what does it mean, actually. Yeah.

32ND WOMAN: Okay, see—

 [Silence]

 • • •

35TH WOMAN: Nice.

45TH MAN: It's something different, isn't it?

35TH WOMAN: Something different, isn't it?

45TH MAN: What is it?

35TH WOMAN: What is it?

45TH MAN: Is that, where I can take it, is it? It is, does it rep-represent anything? [Pause] No? Yeah? No?

35TH WOMAN: No? Well, if it doesn't represent anything, I think it's a waste of time.

45TH MAN: How much did it cost for us to put that there? No? You don't know?

35TH WOMAN: All right.

<p style="text-align:center">• • •</p>

45TH MAN: Well.

35TH WOMAN: Oh, yeah. Well, if it—if this doesn't mean anything, it's a waste of time. If it meant something to Wales, it would be a thing, yeah. Yeah. That's all I can say, really.

45TH MAN: I think we'd be better off with a couple of benches, to be honest.

36TH WOMAN: —week on the telly, wasn't he? It was here, then? I didn't see it then, mind you. I didn't see it then, so no.

46TH MAN: Yeah, um, certainly I never only come to town, so I wouldn't know.

36TH WOMAN: No.

• • •

37TH WOMAN: Sorry. I don't know. No idea.

• • •

47TH MAN: What, what are we what?

48TH MAN: What was that?

• • •

49TH MAN: Just, we've been walking through the city here, for the past couple weeks and we noticed that it was new, and now we're curious. That's it.

50TH MAN: What do you know?

49TH MAN: Do you have any details on it?

50TH MAN: We're just curious.

49TH MAN: Yeah, we're just curious. It looks to seem—it looks to be like a very large object. Wondering how they got it in here, wondering if it has an artistic cause, or if it has a different meaning. Just curious.

49TH MAN: Very neat, thanks for the information. Thank you.

• • •

51ST MAN: What is it?

51ST MAN: [Laughs] What about—I suppose the council put it in, again? What . . . a total waste of money.

• • •

38TH WOMAN: Oh, no thanks.

• • •

52ND MAN: What are you talking about?

• • •

53RD MAN: What is it? I don't know, it looks like a monstrosity to me, and it's got a "Do not climb" thing [laughs], which nobody's going to listen to. So yeah, that

could be, uh, dangerous. Yeah. What is it? Any ideas? [Pause] I don't know. I don't know. I don't know what it is. It looks like a fallen-over hammer. So, yeah. That's all I've got.

• • •

39TH WOMAN: I, I think it's an, an obst—an atrocity.

40TH WOMAN: We're just wondering what it's supposed to represent.

39TH WOMAN: What is it? What, what is it supposed to represent?

39TH WOMAN: Okay.

41ST WOMAN: Responses to that?

39TH WOMAN: I think it's a waste of money.

41ST WOMAN: I think it's, it's black, and it's not exciting. It's just bland, and black.

40TH WOMAN: It doesn't mean anything, does it?

39TH WOMAN: No.

41ST WOMAN: No.

39TH WOMAN: It looks like a hammer that's fallen on its—that's the base, and that's the top, and it's fallen down.

40TH WOMAN: It's fallen over.

41ST WOMAN: Yeah.

39TH WOMAN: Perhaps that's what it's supposed to represent.

40TH WOMAN: And it says on there, "Do not climb." By saying that, people are going to climb it.

39TH WOMAN: And, if it's going to stay there, it doesn't go with the rest of the buildings, especially not the Tabernacle church. Thanks very much.

• • •

39TH WOMAN: Sorry [laughs].

• • •

54TH MAN: Sorry?

• • •

55TH MAN: —don't know. No idea, son. No idea.

• • •

56TH MAN: What is it? [Pause]

57TH MAN: So then, why?

58TH MAN: [Inaudible]

57TH MAN: Oh, sorry, we haven't got time, really, to chat, but
 yeah. Impressed.

· · ·

59TH MAN: Um, big [laughs]. Um, it looks nice. It looks, uh,
 very, um, abstract, I would say. So, okay. That's all
 I've got.

· · ·

60TH MAN: Well, I, I—my reaction is, I'm fascinated by it. I—it
 looks as if it's just landed, and I hope it will soon
 take off, again [laughs].

· · ·

42ND WOMAN: Oh, what is it? Well, it's obviously some sort of
 statue. Do you know what it's for? Or what it's to?

42ND WOMAN: Oh, really? Oh, okay, then. Yeah. Gosh. You don't
 like to say anything. Uh, yeah. Well, it's got me
 talking to you [laughs]. Yeah, no. I—there should
 be something. It says, "Do not climb." No, lovely.
 No. Okay. Well, thank you.

THE SECOND RECORDING | GARTH EVANS

I returned to the Hayes at eight-thirty in the morning. Although the rain had stopped, it remained chilly and wet. I was tired and felt disheveled. After seeing my sculpture returned the previous night, I had gone to bed at two-thirty. I had slept poorly, my sleep filled with monstrous dark forms and images of lights flashing in the rain.

I was there to make a second recording. I had wanted, as much as possible, for the circumstances in which I made the second recording to replicate those in which I had, so many years before, made the first recording. But now, finally there beside the sculpture, microphone in hand, I felt foolish. The entire enterprise suddenly seemed absurd. I was not the same person I had been in 1972, the surroundings were not the same, and the people on the street in the Hayes passing by the sculpture were not the same. The only thing that was the same as it had been forty-seven years ago was the sculpture. Although, in some ways, even that was not quite true.

When the sculpture was placed in the Hayes in 1972, it had stood out like a sore thumb. The work did not fit with its surroundings. It was huge, stark, bold, clean, and assertive in contrast to the setting, which was scruffy, nondescript, and a bit run down. In 2019, the surroundings and the sculpture shared a similar vocabulary: everything was orderly, controlled, designed, and measured. Even so, the sculpture still did not fit. It was cramped, boxed in—it no longer felt like the massive object it had been in 1972. You could not see the whole work; there were too many obstructions—large potted trees, seats, benches, lampposts—preventing one from grasping the total form of the sculpture from any distance. Yet, because it was so large, getting close enough to have an unobstructed view left one able to see only part of the sculpture. In 1972, I had thought the sculpture was "out of place" in a good and important way; in 2019, I felt it was simply in the wrong place.

In 1972, the people I approached were not afraid to speak to me, to speak right to my microphone. In fact, many of them were eager to do so, they wanted to tell me what they thought. In 2019, however, it quickly became clear that people were responding differently. They did not want to be interrupted, they did not have the time or desire to look at the sculpture or to speak to me about it. Time after time, my offered microphone was waved away with a grunt or a brief apology. One obvious explanation for the difference I experienced is that contemporary sculpture in an urban setting is no longer unfamiliar and people were not disturbed by the presence of the work. It was not alien to them and they were neither awakened nor annoyed; they appeared to be simply indifferent.

Of course, I was no longer the relatively good-looking young man I had been in 1972. Then, the sculpture had been rejected, but I as a person asking about the sculpture was not, I was welcomed. In 2019, people generally wanted nothing to do with me and nothing to do with my microphone. The difference I was experiencing may have been due to this simple fact—people were reluctant to speak to an old man without any visible credentials. It is also the case that in 1972, people immediately understood that I was there to ask about the sculpture; in 2019, until I spoke to them about it, many people did not connect me, holding a microphone, with the sculpture.

In short, my experience making the recording transcribed in this volume was profoundly different from my experience in 1972. Making the 1972 recording had been exhilarating—people were animated, lively, and their responses had been delivered forcefully and unapologetically. Then, the thirty-five-minute recording was made in under an hour. By contrast, in 2019, because so many people declined to speak to me, it took well over four hours to make a recording of comparable length. And what a long four hours it was.

I found making the 2019 recording depressing and thought the resulting document would be of little interest, certainly not something so full of life that it might become a book and stage drama, as had the 1972 recording. Yet, listening to the new recording now, I am surprised by it. The audio is certainly not as lively as the earlier version, but it is more varied. As in 1972, most people are uncomfortable, they do not feel able to articulate a response to the sculpture without being given some information about it,

without being told what it represents. But this is not universal—several speakers are interested and one or two are quite knowledgeable about art. One thoughtful person, when asked what he thinks of the object, suggests, after considering the matter, that he should be asked again in six months. Another, a particularly eloquent speaker, reveals that as a boy in 1972, he had climbed on the sculpture. He was not alone; during the time I was in Cardiff I met several people who remembered seeing the sculpture while it was in the Hayes, 47 years earlier.

• • •

The funding campaign and the performances of the play based on the 1972 recording were two events that had offered potential viewers a framework within which to consider the sculpture. This was contrary to my wish to reproduce the 1972 circumstances, in which there was no notice about the sculpture before it appeared. At the time—and still—I had thought that if a person acquired some information about the sculpture, particularly my ideas about it, through some source other than the sculpture itself, this would compromise their response to the work. I wanted responses to the object itself, not to my stated intentions for it. I therefore thought it unfortunate that we had needed a public campaign to raise funds to bring the sculpture back to Cardiff and that, due to last-minute delays in siting the sculpture, performances of the play had to precede its return.

Although I had wanted the object to remain an enigma, it has been pointed out to me that my holding a microphone and asking strangers to speak about something unfamiliar was not just

an invitation, it was also a challenge. It is understandable that, once I was identified as its author, my refusal to share my own ideas about the sculpture could be annoying. I now wonder if it might have been better for me to have asked a different question—instead of "What do you think of this?" I perhaps could have asked, "What does this make you feel?" Or, I could have embraced the new context. Instead of clinging to what remained of the 1972 situation, I could have declared to passersby that the sculpture was a memorial to the 1913 Senghenydd mining disaster in which 440 men and boys had been killed, and then asked if they approved of it or not. This would have provided a sharp contrast with the 1972 recording, but I am not sure what value it would have had. How could anyone have disapproved of such a memorial, other than to suggest that it was in some way or another inadequate? Or that because I had no immediate or direct relation to the disaster, it was not appropriate for me to be the author of a memorial to it.

<p style="text-align:center">• • •</p>

Long before the sculpture was returned to the Hayes, another question had arisen: I needed to understand why I had chosen to put this significant work out of my mind along with the important experience of recording the responses that people had to it. I now think this had to do with the extent to which I was unable to fully identify with the sculpture in 1972. Or, to be more precise, the extent to which I was unable to entirely believe that it was mine—I did not feel the same sort of ownership of it as I did with most of my other works. The work came about during a difficult time in my studio. I had been given an opportunity

though a fellowship with the British Steel Corporation to concentrate entirely on my sculpture for over two years, yet for much of this time I had been unable to bring any work to a conclusion. Sculpture had begun to seem impossible. In the midst of this desperate predicament, the Cardiff sculpture appeared as a gift. It seemed as if I had made no effort to create it. As I reported in *The Cardiff Tapes (1972)*, the work for Cardiff was a fragment ripped out of another work that I was struggling with—a maquette for a commission for the South Wales town of Ebbw Vale. The town wanted a work that would celebrate its steelmaking history. The idea that the sculpture was to have this purpose, the fact of it having this "job" to do, was getting in my way, making it difficult for me to know what I wanted from the sculpture for myself. During this struggle, I had begun to think about what I might make for Cardiff. I had formed the idea that I would like to offer something that could connect with the coal mining and steelmaking industries of the region. Yet I was dreading trying to do this, because it would mean grappling with this same issue again—making a work in which the content was already prescribed, predetermined; it was impossible for me.

Then, suddenly, as if by magic, in a flash, there, laying on the bench, was the Cardiff sculpture! I had no doubt about it, I didn't question what I saw, I knew it. I saw the discarded fragment resting there like a tool I had just put down, like something made to be used, made to serve a purpose. It was a special two-ended hammer, perhaps designed for hitting something very unusual. It was a dark, solid, clear, heavy, matter-of-fact object, familiar, yet strange. It was not heroic. It was not celebratory. It was noble and practical. It was perfect.

I made a larger maquette at a scale of one inch to the foot. Then a colleague and structural engineer made engineering drawings for the fabrication of the work. The final sculpture was made in Birmingham. The completed sculpture was forty feet long and weighed about three tons. Soon after it was delivered to Cardiff, I went to the United States for a visiting professorship, leaving all thoughts of the Cardiff sculpture—and the recording I had made—behind.

Before leaving for the United States, I had completed another work that had engaged me for many months, *Breakdown*, a sprawling, ground-hugging exploded grid of steel bar that had grown to occupy the entire floor of my studio. It presented a way to satisfy my ambition to make a sculpture that did not offer itself to the viewer as an object, as something separate from them and separate from the world. When I returned from my professorship in Minneapolis, I was eager to pursue the implications of this work and made no inquiries about the sculpture I had left behind in Cardiff.

So why did I "forget" this important work and the experiences that I had with it?

The feelings I have now about the Cardiff sculpture began to surface during the preparation of *The Cardiff Tapes (1972)*. I can now see that the Cardiff sculpture embodies, among other things, complicated feelings of anger, feelings that were buried in 1972. At that time, I was angry, irrationally so. I was profoundly frustrated by the difficulty I was experiencing in relation to the invitation to create these two very large public works and with my failure, as

I saw it, to take full advantage of the opportunity given to me by the fellowship with British Steel Corporation. It is clear that I was angry about other things as well, with just being who I was—a young man from a working-class background in the North of England who felt keenly out of place. Almost straight out of art school, I had gained access to the elite art world circles in London though my work. I was enjoying success, exhibiting, and selling my sculptures, but the world I had grown up in and to which I felt I belonged was very distant. I was now estranged from that world, while in the world I was uncomfortably trying to inhabit, I felt like a fraud, an imposter. In part, it was the resulting internal confusion, along with other more personal matters, that had led to the paralysis in the studio. Now, all these years later, after having reconnected with the Cardiff sculpture, this seems obvious.

• • •

In the intervening years, I have not embraced opportunities to create public works. This is not a result of the reception given to my Cardiff sculpture in 1972. It is rather because I did not want to re-engage the discomfort of the impossible struggle I had felt working on the Ebbw Vale commission, and I could not see how to repeat the "magic" that had given me the Cardiff sculpture.

However, returning the 1972 sculpture to Cardiff not only allowed me to more fully understand that particular work and my relationship to it, but the project has also obliged me to think a great deal about the complexities of making work for a public setting and/or a particular community. Once a work of art is exposed to the public, there are two accepted metrics available

to measure its success. In the commercial realm, the metric is sales, and in the public realm, it is numbers of people attending and/or responding. For the artist, neither of these necessarily equates with the success of the work as a work of art. In my own practice, I struggle to reconcile this—the fact that the public perceives my work to be successful, i.e., good, when it is acquired by others and less good when it is not. *Untitled* could have been considered a failure in 1972 because it was not purchased by the City of Cardiff. But I did not and do not consider this sculpture a failure. In fact, I considered it a success in 1972, and I do so even more firmly today.

Artists are most vulnerable when their work is first exposed to the public. My recording the responses of the public to the sculpture in Cardiff in 1972 can be seen as an attempt to capture that moment of extreme vulnerability. This vulnerability would have been reduced if, as is often required today, procedures had been in place to ensure (or at least attempt to ensure) that the work was going to be accepted by the community. As I have made clear, I did not want to try to ensure, in advance of its arrival, that my sculpture would be welcomed. Trying to give the public what they say they want is incompatible with my job as an artist, which I see as giving form to lived experience, embodying experience. As a sculptor, it is my lived experience that I work with, it cannot be someone else's. Experience is what happens to us and makes us who we are, it is not information. Experience, unlike information, cannot be bartered; it cannot be bought and sold. The recording has value in exposing the gap between what I, as the artist, thought of the work and what the audience thought of it. This gap between what an artist produces and what the public is ready to embrace

is not something that society would benefit from eliminating—
it is the measure of something.

Making public work remains highly problematic for me. I am
unable to negotiate with anyone in advance about the form or
content of a work that is yet to be made, and I have a serious men-
tal block when it comes to dealing with bureaucratic authorities.
Yet the issue has come to interest me, and, as a result of return-
ing the 1972 sculpture to Cardiff, I am about to embark on a very
large public sculpture for a development in Guadalajara, Mexico.

As for *Untitled*, after fifty years of being in the world—made for
a particular place, sited, abandoned, then relocated, restored,
and resited—the sculpture has found a fitting and wonderful
home: it now sits on the grounds at the Pontypridd campus of the
University of South Wales, the former School of Mines.

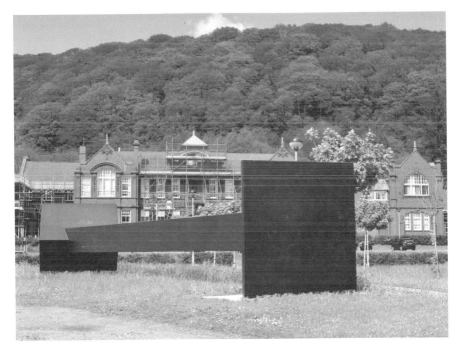

Untitled at the University of South Wales, Pontypridd Campus, 2019.

ANYTHING BUT SIMPLE | ANN COMPTON

Looking back over my collaboration with Garth Evans and Julia Klein, I am struck by a resemblance between the process of writing this book and the process of exhibiting *Untitled* for a second time. Both tasks started with a plan to repeat something that had already happened—in this case the publication of a book with the same format as *The Cardiff Tapes (1972)*—and both projects have proved anything but simple to carry through.

Some of our difficulties stemmed from basic differences between the redisplay of *Untitled* in 2019 and its first showing in the City Sculpture Project. The latter was an ambitious, multi-centered exhibition that was generously sponsored by the Peter Stuyvesant Foundation, and involved fifteen artists who showed work in eight British cities over the spring and summer of 1972.[1]

1 For a full account of this event, see Jon Wood, *City Sculpture Projects* 1972, Henry Moore Institute Essays on Sculpture no. 76 (Leeds: Henry Moore Foundation, 2016). A list of sculptures and where they were exhibited is given on page 6.

The exhibition attracted a great deal of press coverage which initiated a national conversation about the role of public sculpture.[2] In 2019, everything happened on a much smaller scale. Evans and Hannah Firth, Director of Programs and then Deputy Director at Chapter, organized the reinstatement of *Untitled* and the artist's solo show as stand-alone events in Cardiff.[3] There was limited publicity outside of the city and no public programming for either event. The result was that there was hardly any discussion about the 2019 project's larger purpose apart from one article published in 2018.[4]

Faced with this lack of commentary and public interaction, Evans, Klein, and I set about filling the gap by holding extended conversations about the 2019 project among ourselves. Eventually we realized that our discussions were no longer a means to an end but had become an integral part of the book. So, my text is an account of our thinking process rather than the usual neatly rounded interpretative essay. Our hope is that this open-ended approach leaves readers to draw their own conclusions about the redisplay of *Untitled* and to take forward the debate about the 2019 project's place in the practice of public art.

At the start of our collaboration in 2020, my brief was to write about the development of public sculpture in the UK since 1972,

2 For example, the special issue of *Studio International*, vol. 184, no. 946 (July/August 1972).

3 *Garth Evans: But, Hands Have Eyes—Sculpture from Six Decades*, on view September 14, 2019–January 26, 2020, https://www.chapter.org/whats-on/art/gallery-garth-evans-but-hands-have-eyes/3450 (accessed April 4, 2022).

4 Sadia Pineda Hameed, "'The Save Our Sculpture Cardiff Campaign,'" *Wales Arts Review*, December 15, 2018, https://www.walesartsreview.org/save-our-sculpture-questioning-cardiffs-priorities/ (accessed April 5, 2022).

with a particular focus on "issues of funding, requirements for public input, health and safety concerns and the kind of opportunities (or lack thereof) that now exist."[5] I agreed to give this a go but was concerned about the scale of the task. Recent research has shown that between 1970 and 2021, over 4,660 public artworks were installed in mainland Britain and Northern Ireland.[6] This explosion of newly commissioned works eclipses Victorian "statuemania" and the outpouring of memorials to the First World War, which have long been assumed to represent the peak of public sculpture's popularity in the UK.[7] It was clear from the outset that it would be hard to account for such intensive activity in a short contextual essay.

Other issues surfaced as my research progressed. Comparatively few surveys of public art in Britain since 1970 have been published. Of the studies that do exist, most focus on the strengths and weaknesses of public art as a genre, largely through its important, and often controversial, role in urban regeneration schemes.[8] Very little has been written about the practicalities of the commissioning process, and interest in the whole subject of

5 Email from Garth Evans to Ann Compton, September 15, 2020.

6 The research was conducted by ArtUK, which ran a project between 2017 and 2021 to digitize UK sculpture collections and works sited in outdoor public spaces. For further details, see https://artuk.org/about/about-the-sculpture-project (accessed May 30, 2023).

7 ArtUK lists 4,664 artworks dating from 1970 to 2021 compared to 3,356 artworks installed between 1837 and 1970. The latter figure includes 1,297 artworks installed during the reign of Queen Victoria (1837–1901), and 530 war memorials from the 1920s and 1930s.

8 For example, see Malcolm Miles, *Art, Space and the City: Public Art and Urban Futures* (London: Routledge, 1997); T. Hall and I. Robertson, "Public Art and Urban Regeneration: Advocacy, Claims and Critical Debates," *Landscape Research*, 26, no. 1 (2001): 5–26; Claire Bishop, *Artificial Hells: Participatory Art and the Politics of Spectatorship* (London: Verso, 2012); Malcolm Miles, *Limits to Culture: Urban Regeneration Vs. Dissident Art* (London: Pluto Press, 2015); C. Cartiere and M. Zebracki, *The Everyday Practice of Public Art: Art, Space, and Social Inclusion* (London: Routledge, 2016).

public art has waned since 2010 when government spending on the arts was cut back as part of an austerity program.

At first, I thought these omissions added to the value of writing an essay about an important but underrated subject. But as time passed, I found myself questioning the suitability of the topic for this book. I felt that an essay exploring changes to the funding and management of public art projects since 1972 was too large and complicated a subject to sit comfortably alongside Evans' texts and the transcription of the recording.

In any case, it was becoming clear that the book needed to take a broader look at the issues raised by Evans' 2019 project and its place in wider narratives around public art. We were talking and writing against the backdrop of the Black Lives Matter protests that took place in the USA and UK throughout the summer and fall of 2020 following the murder of George Floyd in Minneapolis on May 25. During a demonstration in Bristol, England on June 7, 2020, a statue of Edward Colston, one of the city's most prominent slave traders and philanthropists, was pulled from its plinth and thrown into the city's docks. Footage of the toppling of the statue went viral and helped push longstanding questions about public art's problematic role in racial, identity, and power politics to the top of the news agenda.

We began to discuss the connection between these issues and the 2019 project after a colleague alerted us to an article by Sadia Pineda Hameed.[9] She was responding to the "Save Our Sculpture" crowdfunding campaign, which was organized by Chapter and

9 Hameed, *Wales Arts Review*, December 15, 2018, note 4.

hosted by the Art Fund in 2018, to raise money for the restoration and return of *Untitled* to Cardiff. The campaign's SOS message urged the public to "save" a piece of the city's heritage that needed to be "rescued" from a college campus in Leicestershire and "brought home" to Wales. Hameed saw this appeal to Welsh nationalism as typical of a strategy used by many of Cardiff's contemporary art institutions. She argued that their focus on cultural colonization by the English was disingenuous because it brushed aside Wales' participation in Britain's imperial past and ignored ongoing "cultural erasures" in and around Cardiff.

While Hameed's prime objective was to highlight systemic inequities in the Welsh arts sector, she also directed a number of searching questions at the 2019 project itself. Hameed was particularly doubtful about the idea of "returning" *Untitled* to Cardiff to find out "what a whole new generation has to say about it." The problem, as she pointed out, is that Evans' sculpture had never actually "belonged" to that "new generation" and no one had inquired whether young people actually wanted the work brought back to the city. Overall, Hameed dubbed the 2019 project "inactive traditionalism" and criticized the organizers for their "unwilling[ness] to come out of the past" or "contextualize the sculpture to the present." [10]

We were particularly interested in the question Hameed posed about whether it is actually possible to "return things back to history." This prompted us to consider the way in which Evans

10 Hameed also argued that rather than supporting "academic white conceptualism," "'contemporary art centres' must support & invest in new research, artworks and projects from the 'new generation' itself." She also noted that the younger artists "with the most active, present ideas are often those that are on low-income, part of marginalised groups and have no formal art training or the connections that come with it."

and Firth had approached the redisplay of *Untitled,* and to look for other contemporary works that have been restaged and could be compared with the 2019 project. But when we looked for other reinstallations of public sculptures we were unable to find any recent examples. One reason for this is that many public art installations—like Rachel Whiteread's iconic *House* (1993–4) and Alfredo Jaar's *The Skoghall Konsthall* (2000)—are destroyed after they have been displayed and so cannot be *put back* at a later date. Indeed, it is often the artist's wish that photographs and other forms of documentation are the only physical traces left behind.[11]

Of the smaller proportion of temporary public sculptures that are made from enduring materials and could potentially be reinstated, the overwhelming majority are only exhibited once due to the premium that is placed on newly commissioned work. Of the few public sculptures of this type that have been reshown, most have been installed in a completely different context—for example, Mark Wallinger's *Ecce Homo* (1999), which was sited at the entrance to St Paul's Cathedral 18 years after its initial display on the Fourth Plinth, and Yinka Shonibare's *Ship in a Bottle* (2010), which was moved from Trafalgar Square to a permanent new home at the National Maritime Museum in 2012. [12]

11 See documentation of Rachel Whiteread's *House,* https://www.artangel.org.uk/ project/house/ (accessed April 7, 2022) and Claire Doherty, "Introduction," in *Out of Time, Out of Place, Public Art (Now)*, ed. Claire Doherty (London: Art Books Limited and Situations, 2015), 10.

12 Louisa Buck, "Mark Wallinger's *Ecce Homo* finds new home for Easter outside St Paul's," *The Art Newspaper*, April 10, 2017, https://www.theartnewspaper. com/2017/04/10/mark-wallingers-ecce-homo-finds-new-home-for-easter-outside-st-pauls (accessed December 29, 2021); Mark Brown, "Yinka Shonibare's ship in a bottle goes on permanent display in Greenwich," *The Guardian*, April 23, 2012, https://www.theguardian.com/artanddesign/2012/apr/23/yinka-shonibare-ship-bottle-greenwich (accessed December 29, 2021).

We had more success when we turned our attention to the museum world. Here there is a long tradition of making displays and dioramas that re-present or recreate things from the past. In the early 2000s, this gave rise to a fashion for art museums to recreate past exhibitions and performances.[13] Tate Modern's *Bodyspacemotionthings* (2009) was one such event. We selected it for comparison with the 2019 project because it reenacted a Robert Morris exhibition that had originally taken place in May 1971—the same month that Evans received the invitation to submit a proposal to the City Sculpture Project.[14] In addition, Evans' performative action of standing in the street to solicit the comments of passersby, and Morris's invitation to visitors to explore the exhibits through physical interaction with the objects both arose from a similar investigative process. But the real insights about the practicality of "returning things back to history" came from looking in detail at the organizers' attitudes to the restaging process.

Tate staff took an adaptive approach to *Bodyspacemotionthings*. They worked closely with Robert Morris to make a show that looked like the original but was modified to suit modern display and safety requirements. Some of these changes were significant. They included: the omission of a couple of works judged as dangerous, a much higher level of visitor supervision, and switching the venue from the Duveen galleries in Millbank to the Turbine Hall at Tate Modern.[15]

13 Notable examples of this are Marina Abramović's exhibitions *Seven Easy Pieces* at the Guggenheim Museum, New York, November 9–15, 2005, and *The Artist is Present*, at the Museum of Modern Art, New York, March 4–May 31, 2010.

14 See Wood, *City Sculpture Projects 1972*, 12, note 1.

15 "Seminal Robert Morris Exhibition Re-created for UBS Openings: The Long Weekend," Tate Press Release, April 6, 2009, https://www.tate.org.uk/press/press-releases/seminal-robert-morris-exhibition-re-created-ubs-openings-long-weekend (accessed April 4, 2022).

In contrast, Evans and colleagues aimed to repeat everything that had taken place during the City Sculpture Project as exactly as possible. Considerable effort went into reinstalling *Untitled* close to its original location on the Hayes and obtaining the necessary permissions to enable the sculpture to remain there for six months. A decision was made to omit all signage and interpretive material because none had been posted in 1972. The only exception was a "Do Not Climb" notice required for safety purposes in 2019. This faithful reenactment was completed when Evans stood beside *Untitled* on the morning after the installation and recorded what the public had to say without giving any information about himself or the work.

Based on visitor numbers and press coverage, Tate's more flexible approach produced the better results. *Bodyspacemotionthings* was so popular with the public that its runtime was extended from a long weekend to three weeks, and it attracted over 340,000 visitors. The show also appealed to critics and was the subject of several in-depth articles in the major broadsheets as well as a review in *Artforum*.[16]

By comparison, the response to the redisplay of *Untitled* was distinctly muted—even after making generous allowances for the substantial differences between an exhibition in the Turbine Hall and the installation of a sculpture in a street in Cardiff. There were signs of this when Evans was making the recording and struggled

16 Ben Quinn, "Tate Modern perfects the art of living dangerously," *The Guardian*, July 12, 2009, https://www.theguardian.com/artanddesign/2009/jul/12/tate-modern-robert-morris-injuries (accessed April 4, 2022); and Phyllis Tuchman," Robert Morris, Tate Modern," *Artforum* (November 2009): 242, https://www.art-forum.com/print/reviews/200909/robert-morris-40592 (accessed April 4, 2022).

TOP: Robert Morris, *Bodyspacemotionthings*, 1971. © 2023 The Estate of Robert Morris / Artists Rights Society (ARS), New York. Courtesy Tate Images. Photo: Robert Morris.

BOTTOM: Robert Morris, *Bodyspacemotionthings*, 1971, reconstructed in 2009. © 2023 The Estate of Robert Morris / Artists Rights Society (ARS), New York. Courtesy Tate Images. Photo © Sheila Burnett.

TOP: Heather Peak and Ivan Morison, *Luna Park*, 2010. Steel and polyester, 16 x 8 x 26 m. Installed on Southsea Common, Portsmouth. Commissioned by Chapter, Cardiff in collaboration with Aspex, Portsmouth; Firstsite, Colchester; and Safle. Courtesy the artists. Photo: Matt Sills.

BOTTOM: Heather Peak and Ivan Morison, *Luna Park*, 2010 (post-fire). Courtesy the artists. Photo: Ivan Morison

to find passersby who were willing to stop and say what they thought of *Untitled*. It also showed in the fact that the only press coverage was a couple of short bulletins on the local news at the time the sculpture arrived in Cardiff.[17] Perhaps the project would have attracted more attention if the reinstallation had not been delayed at the eleventh hour. This put *Untitled*'s reappearance out of step with the opening of Evans' show at Chapter so people who travelled to Cardiff for that event missed the chance to witness, and perhaps write up, the realization of the redisplay project.[18] After mulling over these contrasting outcomes, Evans ruefully commented: "I succeeded in taking *Untitled* back to Cardiff, but in terms of what I wanted from this experience, the project was not successful."[19]

However, a second look at the reviews of the 2009 exhibition reveals that Tate was criticized for altering the layout and content of the original show, and for exercising tight controls over visitor interactions with the objects. Several critics felt that the energy and rawness of the 1971 exhibition was missing from *Bodyspacemotionthings*, and one commented that the "radical art of the 1970s has become innocuous family entertainment."[20]

17 Mike Griffiths, "A giant metal sculpture from the 1970s returns to Cardiff," ITV Wales, September 26, 2019, https://www.itv.com/news/wales/2019-09-25/this-giant-metal-sculpture-is-back-in-cardiff-here-s-what-people-think-of-it (accessed April 4, 2022).

18 For example, Sam Cornish's review only discussed Evans' exhibition at Chapter: "Garth Evans: But, Hands Have Eyes," *Studio International*, September 18, 2019, https://www.studiointernational.com/index.php/garth-evans-but-hands-have-eyes-review-chapter-gallery-cardiff (accessed April 4, 2022).

19 Garth Evans, in conversation with Julia Klein and the author, February 16, 2022.

20 Mark Hudson, "Robert Morris' 'Bodyspacemotionthings' at the Tate Modern," *The Telegraph*, May 26, 2009, https://www.telegraph.co.uk/culture/art/art-reviews/5386206/Robert-Morris-Bodyspacemotionthings-at-the-Tate-Modern-review.html (accessed February 16, 2022).

In addition, it is possible to interpret Tate's adaptive approach as a pragmatic response to a historic failure rather than a carefully crafted strategy. The original Robert Morris exhibition was famously forced to close after four days, because gallery staff had completely miscalculated how the public would react and therefore did not make the works strong enough to withstand lively audience interaction.[21]

Conversely, Evans, Firth, et al. had no such infamous history to live down. Indeed, the decision to recreate the original installation of the work grew out of the positive reaction to the publication of *The Cardiff Tapes (1972)* in 2015 and the resulting renewal of interest in the City Sculpture Project.[22]

• • •

As we considered the 2019 project alongside other public sculptures, the shortcomings of thinking about "success" and "failure" in binary terms became even more apparent.

We chose Heather Peak and Ivan Morison's *Luna Park* as the focus of these discussions because it is another public art project that was initiated by Hannah Firth and Chapter. She commissioned this sixteen-meter-tall fiberglass and steel sculpture of an

21 Jonah Westerman, "Robert Morris exhibition, Tate Gallery, 1971; *Bodyspacemotion-things*, Tate Modern, 2009," in *Performance at Tate: Into the Space of Art*, Tate Research Publication, 2016, https://www.tate.org.uk/research/publications/performance-at-tate/perspectives/robert-morris, (accessed April 2, 2022).

22 In 2016, the Henry Moore Institute organized an exhibition, *City Sculpture Projects 1972* (November 24, 2016–February 19, 2017), https://www.henry-moore.org/whats-on/2016/11/24/city-sculpture-projects-1972 (accessed April 4, 2022), with an accompanying publication, Wood, *City Sculpture Projects 1972*, as in note 1.

ultrasaurus in 2008–10.[23] Working with Aspex, Portsmouth and Firstsite, Colchester, Firth planned to tour *Luna Park* to the participating cities, ending up in Cardiff.

At first, everything went well. Over an eight-week period, the sculpture attracted more than 100,000 visitors to Southsea Common, Portsmouth. But then, on the morning of October 1, 2010, the sculpture burned to the ground.

In the immediate aftermath of this catastrophe, the Morisons were in a state of shock. Gradually, their dismay gave way to interest in the "failure" of *Luna Park*. During its brief existence, the "Southsea Dinosaur" had become an iconic part of the Portsmouth skyline and a destination for people who came to enjoy the work, meet up with friends, and photograph the ultrasaurus. To everyone's surprise, in the years after the fire, people regularly placed tributes at the site and posted images and text about the sculpture on social media. *Luna Park* had embarked on a whole new life that was not contingent on the sculpture's existence in material form.

Such was the strength of the public's response that in 2020 Aspex, Portsmouth commissioned a virtual reality ultrasaurus to mark *Luna Park*'s tenth anniversary. The gallery also raised enough money via a crowdfunding campaign to cast a small bronze replica of the sculpture, and this diminutive, permanent

23 "Luna Park," Researchers Archive, Studio of Heather Peak and Ivan Morison, http://www.morison.info/luna-park (accessed April 4, 2022); and "Luna Park, Heather Peak and Ivan Morison," Aspex, Portsmouth, https://aspex.org.uk/exhibition/luna-park-heather-and-ivan-morison/ (accessed April 4, 2022).

"memorial" to *Luna Park* was installed on Southsea Common in 2021.[24]

• • •

Although this colorful story clearly shows that the reception of a public sculpture is an unpredictable business, it was hard for us to see how the fate of *Luna Park* had any bearing on the redisplay of *Untitled* because the two works were conceived in such radically different terms.

The Morisons set out to make an engaging, eye-catching sculpture. To pique the public's curiosity, they chose a dinosaur that bridges fact and fiction as the work's subject, and modeled its style and size on an American "traffic stopper" (huge roadside figures designed to encourage drivers to stop and buy things).[25] In a further nod to popular culture, the Morisons named their sculpture "Luna Park" after an amusement park in Novosibirsk, Siberia, which they had visited in 2005.[26]

Evans, on the other hand, was (and still is) happy for *Untitled* to remain something of an enigma. For this reason, Evans chose in 1972 not to disclose the fact that he saw *Untitled* as a memorial

24 "Bring Back the Southsea Dinosaur," Crowdfunder, https://www.crowdfunder. co.uk/southsea-dinosaur; and "Luna Park 2021," Aspex, Portsmouth, https://aspex. org.uk/exhibition/luna-park-2021/ (both accessed April 4, 2022).

25 For a short history of the ultrasaurus see Bayard Webster, "Paleontologist in Colorado Finds Evidence of the Biggest Dinosaur," *New York Times*, July 31, 1979, https://www.nytimes.com/1979/07/31/archives/paleontologist-in-colorado-finds-evidence-of-the-biggest-dinosaur.html (accessed April 4, 2022).

26 This account is based on https://peakmorison.org/Luna-Park (accessed April 4, 2022).

to the 1913 Senghenydd mining disaster. He also kept quiet about the formal relationship between *Untitled* and a sculpture he was making for the steel-making town of Ebbw Vale. Although these details are now documented in *The Cardiff Tapes (1972)*, Evans still hopes *Untitled* will challenge rather than inform the viewer. Indeed, if the sculpture could speak, he imagines it might say, "I'm going to make you ask a question. I'm going to make you wonder what's happening. I'm going to make you, in some way, become more alert."[27] Clearly it is not a simple matter to engage the public's interest in, and approval for, a work that aims to perplex and provoke.

Despite these marked differences, we caught a glimpse of common ground when our discussion turned to the destruction of *Luna Park*. In the aftermath of the fire, the police were called in because arson was suspected (though never proved). At the same time, the Morisons were having to make decisions about the fragments of twisted metal and shreds of the polyester shell, which were all that remained of their sculpture. It quickly became clear that there was neither the time nor the money to commission a replacement ultrasaurus. This meant there was no *Luna Park* to complete the tour to Colchester and Cardiff, and therefore nothing for the critics to assess. Significantly, the Morisons' reaction was not to try and hide this difficult situation; instead they talked about it openly.[28] It was their willingness to acknowledge the vulnerability of their position that caught our attention and led us to reexamine the way Evans made his second recording in 2019.

27 Garth Evans, in conversation with Julia Klein and the author, February 16, 2022.
28 See Heather Peak's contribution to the 2015 recorded discussion, "Whitechapel Gallery | Out of Time, Out of Place: Public Art (Now)," https://www.youtube.com/watch?v=gP8cwZFa1GE (accessed April 4, 2022).

The conventional method of engaging people in a public art project is for the artist to hold a series of meetings with local residents during an initial research process. The artist then draws on the information supplied by the public to make a work that is embedded within that particular location. Evans' starting point was very different. Not only did *Untitled* already exist before he looked for public interaction, but when he began the recording, Evans kept quiet about his identity and simply asked people, "What do you think?" This reticence passed unnoticed in 1972, but it put him directly at odds with expectations about public disclosure in 2019.[29] Evans was willing to risk being out of step with current practice to avoid passersby feeling inhibited by the knowledge that he was the artist. He wanted people to speak freely about the work so the recording could fulfil its purpose of documenting the public's candid reaction to a sculpture at that pivotal moment when it leaves the seclusion of the studio (or, in this case, the conservator's workshop), and is launched into the world.

Evans has shown a similar open-mindedness in conversations with Klein and me, and has spoken frankly about the problematic aspects of the 2019 project. His commitment to transparency flows through the texts in this book, and especially in the unedited transcript of everything people said or declined to say in the recording (regardless of how difficult or uncomfortable that might be). Ultimately, it is this willingness to talk freely about the existential challenges that artists face that links Evans' and the Morisons' approaches. Their words are powerful because they

29 Hameed (2018, note 4) was the first to query Evans' decision to conceal his identity as part of more general criticisms about the linguistic framing of the crowdfunding campaign.

remind us that public sculptures carry the visible and invisible traces of a private journey undertaken by the artist. And that every step of that journey—from the sculpture's inception in the studio through to its life in the public domain—is fraught with difficulties and uncertainties over which the artist has very little control. Bringing these hidden stories about public art practice into the critical discourse is an important step because it gives us a more rounded picture of the commissioning process, and, in doing so, suggests new ways of engaging with public sculpture.

ACKNOWLEDGMENTS

I AM IMMENSELY grateful to everybody who helped make the Cardiff project possible, including all of those individuals mentioned in "Returning the Sculpture," the first essay in this book. In particular, Jon Wood, who introduced me to Julia Klein, for his interest and insight. And Julia, for her enthusiasm and support in publishing *The Cardiff Tapes (1972)*, together with this subsequent book. Tony Stokes and Hannah Firth for their faith and commitment. Ann Compton, not only for her thoughtful contribution to this volume but for her helpful questions during the process of bringing it into being. The staff at Chapter and at the Art Fund, together with the many people who contributed to the campaign to return my sculpture to South Wales. In addition, I must mention the people who brought the 1972 tape recording to life as a stage play: Leila Philip, who wrote the script; John Van Ness Philip and Andrew Resto, who worked wonders to put it on stage in New York City; and Wayne Vincent, working with the spirited and historic Everyman Theater, who did the same in Cardiff. I also need to thank my brother, John Vaughan Evans, who organized a family reunion on the occasion of the opening of my exhibition at Chapter, as well as the many friends who traveled to Cardiff, some from a considerable distance, to attend the opening and see the play. Last, but by no means least, I am grateful to Rhys, my son, for his unfailing good humor, his consistent support, his culinary skill, and his willingness, always, to lend a hand.

GARTH EVANS (b. 1934, Manchester, UK) studied at Manchester College of Art (1955–57) and Slade School of Fine Art, London (1957–60). A central figure in the narrative of British sculpture, Evans exhibited in the influential group exhibitions *British Sculpture '72*, Royal Academy of Arts, London (1972), and *The Condition of Sculpture*, Hayward Gallery, London (1975), and he taught at St Martin's School of Art, where he was one of the architects of the legendary "A" Course (1969–73). He has taught at a host of other institutions as well, including Slade School of Fine Art, Royal College of Art, Yale University, and the New York Studio School. Evans moved to the United States at the midpoint of his career in 1979. He has presented work in over one hundred solo and numerous group exhibitions in galleries and institutions on both sides of the Atlantic. In 2013, artist Richard Deacon curated the survey exhibition *Garth Evans* at Yorkshire Sculpture Park, which coincided with the release of *Garth Evans: Sculpture Beneath the Skin*, ed. Ann Compton (Philip Wilson Publishers, 2013), a major publication reviewing his career to date. Evans has received numerous awards and residencies including a Fellowship with the British Steel Corporation, 1969-71 and a Guggenheim Fellowship, 1986. His work is represented in major public and private collections, including Tate Britain, the Metropolitan Museum of Art, the Museum of Modern Art, the Victoria & Albert Museum, and the British Museum. In 2018, Evans began Sculpture Forum (www.sculptureforum.net), a project that promotes the discussion of sculpture amongst sculptors, and with educators, critics and other artists. Evans currently lives and works in northeastern Connecticut.

ANN COMPTON

ANN COMPTON is an art historian, curator, and independent scholar. In 2014, she was awarded a Senior Fellowship by the Paul Mellon Centre for Studies in British Art, and she has been an Honorary Research Fellow at the University of Glasgow since 2006. Compton sits on the Advisory Board for the *Sculpture Journal* and is a Fellow of the Society of Antiquaries. She has previously advised ArtUK's "Your Sculpture" project (2013-21), and the University of Barcelona's international research program "Mapa dels oficis de l'escultura, 1775–1936. Professió, mercat i institucions: de Barcelona a Iberoamèrica (2014–16)." During the early part of her career, Compton worked as a curator at Kettle's Yard, Cambridge; the Imperial War Museum, London; and the University of Liverpool Art Collection, where she organized contemporary and historical art exhibitions. Since the early 2000s, Compton has focused on academic research. She developed, and later directed, the digital humanities research program "Mapping the Practice and Profession of Sculpture in Britain and Ireland 1851–1951" at the University of Glasgow. Compton has written widely about sculpture from the early nineteenth century to the present with a special interest in the materials and processes of sculpture, sculpturally related businesses, and contemporary public sculpture. Among her recent publications are essays or shorter texts on William Turnbull, Barbara Hepworth, and Henry Moore. In 2013, Compton edited the multi-authored monograph, *Garth Evans Sculpture: Beneath the Skin* (London: Philip Wilson Publishing).

THE CARDIFF TAPES (1972)

BY GARTH EVANS
TEXT BY JON WOOD

In 1972, artist Garth Evans welcomed the opportunity to create a public sculpture in Cardiff, Wales, as part of the Peter Stuyvesant Foundation's City Sculpture Project. Concerned that the increasing demand for his work served only to reinforce the political, social, and economic status quos, Evans hoped to unsettle this dynamic by making a sculpture that would connect with an audience outside of the art world. The morning after the installation of his sculpture, Evans recorded the responses of passersby. The Beckettian transcript of the Cardiff interviews is presented here, framed by Evans's introduction and reflection. Art historian Jon Wood contextualizes *The Cardiff Tapes* within contemporaneous debates about sculpture and public space. These writings explore ideas about the social responsibilities of art and artists and make a cogent argument for the value of "difficulty" in sculpture.

Available from Soberscove Press
978-1-940190-08-2 / 2015 / 5.5 x 8 in. / paperback / 90 pages / 10 color & 5 black-and-white illustrations / $16